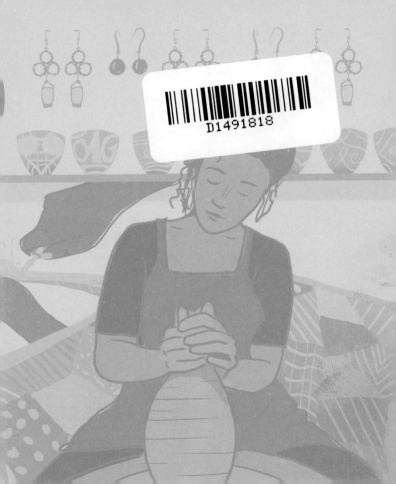

Mindful thoughts for
MAKERS

First published in the UK and North America in 2019 by
Leaping Hare Press
An imprint of The Quarto Group, The Old Brewery,
6 Blundell Street, London N7 9BH, United Kingdom
T (0)20 7700 6700 **F** (0)20 7700 8066
www.QuartoKnows.com

British Library Cataloguing-in-Publication Data
A catalogue record for this book is available from the British Library

ISBN: 978-1-78240-883-3

This book was conceived, designed and produced by
Leaping Hare Press
58 West Street, Brighton BN1 2RA, UK

Publisher: *Susan Kelly*
Editorial Director: *Tom Kitch*
Art Director: *James Lawrence*
Commissioning Editor: *Monica Perdoni*
Project Editor: *Claire Saunders*
Illustrator: *Lehel Kovacs*

Printed in China

1 3 5 7 9 10 8 6 4 2

Mindful thoughts for
MAKERS

Connecting head, heart, hands

Ellie Beck

Leaping Hare Press

Contents

On Being a
Maker

Being a maker is an innate part of our human experience, something we are born with, but many of us seem to have forgotten this. The busyness of our lives, the rush of society's expectations and the increasing use of technology all pull us away from the work of connecting our hands with our heart.

Our ancestors were makers, without even naming themselves as such. And we are all makers still, whether we are knitting a garment, turning wood on a lathe, hand-crafting a pair of earrings, decorating a cake or sewing a special quilt for our family. Makers aren't necessarily artists or crafters, in the sense of what those words might mean to you. They are simply people who

tinker, design, invent, create, play, explore and make something. Makers can be artists, bakers, potters or ceramicists, jewellers, woodworkers, gardeners, sewers, tailors or dressmakers – the many creative activities that fit under the term 'maker' are too long to list. To be human is to be a maker.

In our busy lives, we makers create many things, yet we don't always lean into the stillness and quietness that can come from the experience of making. We rush to finish our project, to show it off on social media, to buy more materials to make something else, and the cycle of producing things continues. Yet, wouldn't it be beautiful if we could bring 'slow' into our days and our lives, through the very simple act of learning how to enhance mindful moments in our making? To change our routines into a rhythm, and to replace the rush to finish a project with the quiet slowness of taking time to enjoy it. The process of making things can guide us to slow our breath and our bodies, to listen to our minds and connect with the whisper in our hearts.

Being a mindful maker can allow us to follow the curiosity of seeing where the journey might take us, to discover what we can learn about ourselves and our environment, and to change our outlook on life through the lessons that making can teach us.

My experience as a maker is so deeply ingrained in my daily life that sometimes I have to remind myself to use my making as a tool for my daily meditation, to still my mind and body, rather than simply making for making's sake alone. I can use my needle and thread to create small pockets of quiet time and to guide me into bringing more mindfulness to my whole life – to remember the way I feel when I'm quietly stitching and bring that feeling into the hectic noise of my days.

By sitting with our practice, as a maker, and allowing our rituals and rhythms to guide us, we are able to delve into a deeper connection with being a maker, with our materials and tools, with the environment around us, and ultimately with our broader community, through a more intense sense of fulfilment and contentedness.

The Heart
of the
Maker

The term 'maker' encompasses so many possibilities and such a variety of crafts and creative practices, media, projects, skills and techniques, that it's almost impossible to narrow it down to any one group of people. Put simply, a maker is a person who makes or produces something, but I think it goes much deeper than that. I believe that we are all makers, if only we'd give ourselves permission to become one, and do away with any rules of what a maker has to be.

Human beings are makers by nature, from our pre-history right through to today. Setting the intention

to make something is about tapping into our innate creativity, re-learning the things that a generation seems to have pushed aside in favour of a mass-produced world, and sharing our unique visual voice with our fellow humans. Being a maker can be as diverse as sewing ourselves a new outfit, constructing a lightshade, building a tree house or forming clay into pots. The wonderful thing is there are no rules for what a maker is or has to be, and no expectations that you should only make one sort of thing for your whole life. Indeed, you don't even need to be very good at making, in order to be a maker.

The important thing, in my mind at least, is that you need to enjoy the making – that at least some of the time you find satisfaction and inspiration and perhaps even discover yourself in the things you make. You don't need to finish your projects or share them with the world to be a maker. The heart of the maker lies not in the finished items, but in the doing of the project, the making of the thing.

WHY WE MAKE

Humans have been making since time began, to meet our daily needs such as gathering food and sheltering our bodies, and as an artistic outlet to tell our stories or share our experiences. We make today for many similar reasons. Many makers the world over create something because deep down they have a feeling, an urge to share a story, to show their thoughts, feelings or emotions.

Growing up in an artistic family I never thought much about why I make, but looking at the world now and the increasing numbers of people turning to making, I realize that why we make things today is also quite different to the reasons our ancestors did. While for them it was a necessity to make their own soap, quilts, bread, clothing and furniture, today we can easily and cheaply buy those things with little thought of how they were produced – sometimes by a person, sometimes by a machine. Mass-produced, generic stuff fills our lives, and many of us have started to notice a disconnect from our possessions, and a disquiet about

the environmental effects of our modern life. These feelings, combined with a generation of children who didn't learn basic sewing and other making skills from their two-parent working families, have led to a dramatic shift towards DIY, craft clubs, online forums and creative community collaborations.

Thanks to the Internet, makers can now share, learn and connect worldwide, inspiring a younger generation of makers, while learning from peers or an older generation. The increase of at-home ceramics studios and newly skilled spoon carvers or basket weavers is indicative of the modern maker. Our ancestors made these items for everyday use, for mundane moments or creative rituals, and today makers are picking up the tools, attending a workshop or asking the advice of a long-time maker from their community. We are doing this to tap into the truth of how things are made, and to honour the history of our regions, all while mindfully giving up on mass-produced items that have a cost both to the environment and to the communities forced into making them.

MINDFUL MAKING

Being a maker can be as joyful as using our hands to create something. But by connecting our head and heart to the process, through mindful thoughts, we can tap into a richer depth of our creative practice. The act of joining hands, heart and head together creates something bigger than ourselves, while also allowing us to better understand ourselves. The things we make with our hands have the power to create change in our minds and our hearts.

Being a maker at heart is often about more than the act of using your hands to make something: deep in ourselves, there seems to be an underlying sense of why we make something, how we make and the connections we create through the journey.

Honouring
the Rituals

Being a maker in this modern world means actively stepping away from social or traditional media, from the emails and online inspiration, and finding our own space to slip into our creative work. Many artists, poets, writers and makers have rituals or routines that help bring focus and clarity to their mind. While history tells us that many artists – particularly writers or painters – used drugs or alcohol to help them fall into their states of inspired work, you can find other ways that will work for you.

The rituals of everyday tasks can be used to help slow down your mind and get it ready to settle into work. The simple act of boiling water and getting out a special

cup ready for your morning coffee helps to create a bridge between the busy, noisy turmoil of your world and the quiet space of making, allowing you to focus on those parts of your mind where creativity dwells. The ritual helps to form the habit. Setting yourself the mindful task of brewing coffee or tea tells your mind that your creative time is now. Like beginning an exercise routine, once your mind and body knows where the ritual leads, you are more likely to easily slip into creative mode.

You must choose for yourself which acts will become the bridge between everyday life and that space where you find quietness for your creative flow. It might be walking in the garden, practising deep breathing techniques, listening to music, watching the sun rise, doing ten sun salutations on your yoga mat, having a bath, writing in your journal, getting dressed for the 'studio' (even if your studio is only the kitchen table) – what it all leads to is finding what works for you and your creative practice.

Of course, the act of making coffee can be a dreary mindless routine if you don't honour it and give it space to become a ritual. While the water boils, use the time as an opportunity to allow your mind to let go of life's dramas, the sleepiness you feel, the children bickering, the bills to pay or the job you may later need to get ready for. Taking this special time for yourself, and your creativity, helps to give you space in your day and your life, to honour yourself in a mindful manner. The ever so simple act of making a hot drink for yourself comes to be filled with such meaning that you give it a reverence often reserved for a Japanese tea ceremony.

A DAILY CREATIVE RHYTHM

For some people, it may be the time of day you set aside for making that creates the ritual of easing your mind into creative mode. Using quiet blocks of time to create without any obstacles is common amongst many creatives who work around life, family or a job to do what they are passionate about. Staying up late in the

solitude of the night to work while your family sleeps, or waking up early in the dark before dawn to sew, carve or quilt, might sometimes be a necessity, but it can also become a rhythm to a creative practice. The ritual of daily rhythm is not to be confused with routine, which can be mundane and not inspiring at all. Having a rhythm to our days is more lyrical and allows more flow than having a strict schedule or routine to follow.

DEDICATION TO PRACTICE

After time we find that ritual leads to the dedication of our practice. While it is not always understood how rituals work, and many might find them hard to explain, it has been proven that through these repeated acts we can actually get down to good, solid work. Some rituals, such as setting ourselves the task of writing 500 words a day or throwing 50 pots on a wheel, can even put us in good stead to learn the art of our craft better. Practising our craft is not only about learning but about dedicating to our work. An arts

practice becomes a habitual process through the continued rituals of doing, and through committing time, space and creative energy to ourselves. Through mindful rituals we can come to a place where the habit of our creative work steps in. Accessing our creative flow through ritual over many months or years guides our brain and body to know where our work can begin.

The simple act of winding the yarn, priming your canvas, mixing the paint, kneading the clay or even sweeping up the wood chips from yesterday's making guides our minds into the quietness we so crave as makers. And in that quietness we find the space to keep on making.

Remembering
to Breathe

One of the downfalls of our modern lifestyle is the speed with which we seem to do everything, including breathing. With the increasing amount of stress in our society, we have seen a rise in thoracic, or shallow, breathing. Every day we race about, sucking air in through our mouths and puffing it out – in a fight or flight mode of living that results in stress, anxiety and numerous medical conditions, and doesn't allow for connecting to slower thoughts or moments.

BREATHING AND CREATIVITY

It seems many of us have forgotten how to breathe, and how vital deep and slow breathing is for our whole state

of wellbeing. The majority of humans breathe using less than 20 per cent of their full lung capacity, despite the fact that as newborn babies we naturally breathed deeply right down into our abdomen. Deep breathing is said to slow down our heart rate, lengthen our lives and give us clearer mental capacity. By contrast, shallow breathing is the body's response to danger, which is useful for short periods of time, but means we aren't getting the levels of oxygen our bodies need to stay at optimum levels of health. This results in a decrease of brain function, which inhibits our creativity, focus and abilities to solve problems – and all creative people are problem solvers.

The word 'inspiration' comes from the Latin word *inspirare*, which means 'to breathe'. To give ourselves a better chance of staying inspired, deep breathing practice is an excellent addition to our creative practice, while also being a simple yet powerful tool to help us slow down in an overstressed society and instead connect with the moment.

THE HABIT OF MINDFUL BREATHING

Breathing into the full capacity of your lungs is the foundation of meditation and yoga, but it can also be practised through your daily making. Using your creative work as the reminder for slow and deep breathing will help guide you towards a healthier body and mind. By routinely incorporating deep breathing into your making activities, it can become a necessary, habitual part of your creative practice and your life.

Actively focusing on your breath is the first step, noticing when you are breathing deeply or only taking shallow breaths. The quality of your breathing can change depending on what your creative practice is, but sitting up straight while you work helps with better breathing (not to mention posture and back problems). Sitting hunched over your potter's wheel or sewing machine or curled up awkwardly with your crochet isn't ideal for long periods of making or for deep breathing. Setting up your workspace carefully, such as adjusting your chair and table height, makes a difference to the

ease with which your body will cope with extended periods of making. And while it might not be practical to always sit straight or mindfully, it's possible to keep remembering to tend to your posture, with practice.

TUNING OUT AND TAPPING IN

In my hand-stitch work I like to think of the process and sound of needle and thread pulling through the fabric, as the foundation for my breathing. I often notice when I am a little stressed that my stitches are rough and ragged, whereas when my breathing slows down and I settle into a peaceful, mindful rhythm of creative work, each stitch smooths itself out, sitting more neatly beside the next. I can notice the difference over a short time frame, as my mind withdraws from the scurrying of life around me, and I begin to practise mindful breathing and focus on what's in my hands. The state of your own mind could show itself to you in the tension of your knitting or crochet, the centredness of your thrown pots, or, like me, the evenness of your

stitches. The joyful benefit, for me, is when the process of my work guides my breathing to become more mindful, and then in turn my slower, deeper breathing allows my work to be more considered.

By focusing on your breath you'll also learn to listen to your mind a little better, tapping into the stillness and learning to watch the way your creativity ebbs and flows. Mindful breath gives you something to return to when your mind wanders, your thoughts scatter and you slip into negative chatter about your creative work. Breathing with intention seems to help in dispelling negative thoughts, and returns us to simply enjoying the moment of making with our hands.

By breathing deeply to the bottom of your lungs, you are giving your body the oxygen it needs to recover from any stresses of your day. If you have a regular creative practice, building deep breathing into the rhythm of your making will be an opportunity to nurture your body and mind, while creating something meaningful with your hands.

The Quiet
in the
Making

One of the joys of being a maker is finding moments of quiet space to create our work. In this ever-busy world we live in, sometimes stepping away from the noise can help us to find a deeper sense of meaning in our work. While it is true that not every aspect of our creative lives needs to be imbued with hushed tones, it is beneficial for our minds and our work when we actively seek the internal quiet.

The chatter of a knitting circle or a companion in your studio or at your kitchen table is always a welcome addition to the pleasure of sitting and creating

something. But if you are always in company, with noise around you, it makes it harder to find the space needed to contemplate the depth of your creative work. Stepping outside group activities and sitting by yourself in the quiet of the day is an important part of any maker's process. It might seem hard to replace the enjoyment of creating alongside someone else with the endless silence of working alone, but once you have experienced your internal quiet it makes those moments seem more profoundly special, and something to seek out.

INSPIRATION FROM WITHIN

Conversations with our inner self during moments of creativity give us a deeper insight into who we are, and how we fit into the human world. Being a maker gives us the opportunity to delve into aspects of ourselves that are often overlooked in the everyday noise of life. It gives us a chance to tap into our innate creativity and ignore the external critics while we immerse ourselves in the joy of making. Of course, not every craft has the

opportunity every day for quiet self-reflection, but unless we try to bring some moments of quiet into the act of making, we may end up spending too long looking outside for inspiration, rather than finding it internally.

Noticing which techniques during your practice best fit the quiet, mindful flow of internal conversation means you can schedule those practices during times when no one else is around. The quietest times in your day can coincide with the more mindful aspects of your practice. Working within the creative zone allows for things to flow without being over-analysed or self-judged. This can often result in sheer beauty in the finished piece – and at the very least you'll have had a peaceful session at your work table.

FINDING YOUR INTERNAL QUIET

The rhythmic whirl of a potter's wheel, the click of knitting needles, the thrum and whir of woodworking tools, the scratch of pencil on paper, the scrape of paint

across cloth. Noticing these aspects of your daily work helps to guide you into a state of mindful contemplation. When you focus your mind on one noise or thing, your heart tunes into the sound of your creative work and you can slow time to just that moment. Next time you're at your work table or in your studio, try to work without the radio turned on or a podcast playing, and see if you can tap into the quiet sounds around you, without holding onto any of them. In Zen meditation, a beginner is asked not to ignore the external world but instead allow it to wash over them – to know it's there, but not bring it into their practice.

Leave aside any inspirational books, websites or paperwork, and see what evolves when you choose to give yourself quietness in your creative practice. External distractions have a way of cutting into our creative process, stopping the flow of our work and sometimes, sadly, disrupting the magic that can result from working within the quietness of ourselves.

BRINGING QUIET
TO A NOISY WORLD

To learn, through practice, how creativity and being a
mindful maker can slow your mind, shows us ways to
live in quietness and find contentment in the quiet,
mundane moments of our life. When you listen to your
own heartbeat, and understand your breath, you can
take this practice into the world and utilize it to bring
slow mindfulness into everyday life. Until you've tried
this yourself, it might seem strange or too hard to do,
but through regularly seeking the quiet in each day,
you'll learn that you can take that quiet into the
busyness of the world. Teaching yourself to tune into
the stillness around you, perhaps watching a raindrop
fall from a leaf, you'll find that you will continue to
actively seek stillness and quiet when faced with a
regular day of noisy, stressful moments. Using the
calmness that making can give you, and understanding
that it is possible, you will find a new way of being.

Experimenting

Putting ourselves in a situation to experiment with our work opens our eyes and hearts to different possibilities. To make what others may consider a technical mistake is about testing the boundaries of ourselves through our creative practice. When we step past the safe bubble of familiarity, in which we always know the answer, we are able to grow in our creative practice as well as our personal lives.

LEARNING TO LET GO

Consciously allowing the natural errors that can often occur when we are learning something new can guide us in our practice, even when we are more experienced.

Remembering those days when we made mistakes as a beginner can help us today to keep learning new things in our craft, regardless of how many years we may have been practising. Sometimes the experiments of a beginner can create more uniquely interesting work than the over-practised outcome from a master.

By bringing an experimental aspect to our work, we can start to notice and appreciate the innate beauty in the imperfections of our lines, marks, stitches or strokes. Allowing our work to evolve by letting go means we can discover a deeper layer to our internal voice. By going with a natural flow, without over-thinking or over-working things, we can find that our creative work has the potential to have more meaning, more feeling, more depth and ultimately more of ourselves in it.

Making experimental work can be hard in many ways. We find it difficult to let go of our ego in order to 'be wrong' or not create the 'good' work we are used to doing. It is also hard to simply let ourselves be free enough to not force the outcome to where we think it

should go. Being mindfully present in the activity can help to overcome what could be a rigid process. Giving ourselves space and time to see where the experiments might lead allows us to experience the joy that is part of this act of letting go.

A good way to begin experimenting is to use your materials or tools in a new, different or 'wrong' way. Making crochet or knitting stitches with the wrong size yarn-to-hook ratio, for example, can often bring about fantastic errors in the tension and shape of worked fabric, which rather than perhaps being perfectly wearable can instead become a wall hanging or the inspiration for a new piece of wearable art. You could try using the wrong paper for making a book, the wrong ink on fabric, or the wrong glaze on your pot. Or attempt painting with your opposite hand, or perhaps with your eyes closed. Using a completely new material that you've never tried before, or exposing it to different techniques, stretches you past the rules of what others might dictate.

LESSONS FOR LIFE

It takes a certain courage to experiment, and step out into the wildness of creativity – to give yourself space to put the 'wrong' mark, to use the 'wrong' yarn, clay, waste paper or piece of wood for carving. It's scary to be adventurous in this manner, but many of us creatives know that it is by pushing through the fear that we better come to know ourselves in our arts practice. It is when we step past the boundaries of what we know, in our making practice and in our emotional lives, that we can grow as humans into our full selves.

Scientists conduct experiments regularly, expecting mistakes, in their quest to learn new things. Perhaps as makers we can follow that example to continue our creative experiments, documenting our results and changing the way we do things in order to discover new outcomes in our work. Deliberately changing the rules, creating errors in how we work, adding new materials or tools, is a way to step past the comfort zones we create where we always know the answer.

Giving ourselves the opportunity to see where unexpected experiments in our creative practice might lead us may result in materials or even time being wasted. But it also allows us to discover a way of working that connects us deeper with our internal selves and our joy of making, and guides us on a new path. Experimenting with our making practice may lead to experiments in our wider lives: at work, in our relationships, in our clothing or hair styles, and in our approach to our own lives. Changing, growing, learning and re-learning are things we have the chance to do everyday, but by sticking to our same routines and never stretching past our safe zones we can't easily find a way to step into a different way of approaching our life, or experience being more deeply in tune with ourselves.

Creating
Time

Finding space to fit our creative work around our life, jobs, families and downtime can be a little stressful at times. Either we want to rush everything else to give ourselves as much time with our making tools as possible, or we feel guilty when we take time away from others to fulfil our own creative needs. It doesn't seem to make a lot of difference whether you are a full-time professional, occasional hobbyist or somewhere in between. The time and space for our creative work doesn't just magically appear, and we must work at creating a space for ourselves.

It seems vital, to me, that rather than accepting the negatives of having too little time and being pulled

away from our need for making, that we should instead approach time peaceably, actively making room in our lives for what matters to us. The world seems ever busier, with time spinning away from us, and we cannot afford to lose focus and drift off mindlessly or we may one day look back and wonder where our days went. Being busy without purpose is not a hallmark of importance, but rather an indication that we are not paying attention to our days in a thoughtful, considered way. Letting work or external commitments drag us away from what we want to do, leaving us ragged and rundown, gives little space for our making or our commitment to a slower, simpler way of living. Being busy is sometimes a resistance to other things, and a clear indication that you need to slow time down in a meaningful manner. As a traditional Zen saying goes, 'You should sit in meditation for 20 minutes a day – unless you're too busy, then you should sit for an hour.'

Being mindful in our creative practice, by actively choosing to prioritize the space and time for ourselves,

brings attention to our internal core. Focusing on even just one thing makes us slow down a little from the rush of everyday life. Mindful making is about more than simply stitching or knitting something beautiful; it is about learning how to bring that focus or feel of attention to something (the stitch work, the pattern) in our daily lives.

MAKING TIME FOR MAKING

Rather than waiting and hoping for moments of time to appear in which we can sit quietly and make, it can be beneficial to factor those times into your week, to actively choose to give space to our creative work. By setting an intention for yourself to attend to your creative making with daily practice, you will be giving yourself the priority that you deserve. Like any other appointment or meeting scheduled into your diary, a space for your creative practice can fit in.

One practical aspect of making time is to always be ready for your little pockets of space. Being organized

in your workspace leads to clearer headspace and allows you to jump right into the physicality of making, rather than dealing with the mess of last week's session. Having materials and tools ready to start work means you can settle into the zone of making more easily.

STARTING SMALL

Sometimes all it takes is the intention, and you make it work. Other times you need to really focus and dedicate to ensure that your making time fits into your day. Starting small is a good way to begin. Setting achievable ideas of how you can work around other commitments, and being mindful to your family, work or regular day-to-day tasks, means that you won't keep filling up the time you want for your making with other things.

In any practice where we need to put aside time, it does take dedication to keep it up. Working in small pockets of time is an ideal way to start, so long as you are able to slip into your creative work mindfully and don't just feel stressed and clock-watching. Coming

each day to our practice trains our minds how to swiftly pick up where we left off, to find the tail end of our quiet conversations. And giving ourselves permission to do small amounts of creative work can have a trickle-on effect of us doing a little more each day.

As with yoga, meditation or indeed any exercise, a small amount of tending to our creative work is always better than none at all. Some meditation teachers say that if you only have 10 minutes, that is enough; it is better to begin with what little time you might have, rather than wait for a longer block of time that might never arrive.

Making
& Ego

Being a maker means we, usually, share our work with others, either in our family, community or the wider online world. This can be both wonderful and difficult, depending on our connection with our work, how our sense of identity is represented in what we make, and our feelings of self-worth – our ego – in general.

Ego needn't be a bad word, but we all know someone who is led by their overly egotistical personality, which can make us feel a little uneasy allowing our own work to be complimented or even talked about. Coming from the Latin word *ego*, meaning 'I', a healthy ego is a vital part of human nature. Our ego signals our sense of self-esteem or self-importance. Finding the right

balance between self-worth and over-confidence can be a journey towards better understanding who we are.

By immersing ourselves into our practice as makers, we can find our quiet internal voices to guide us along a path where ego plays a part of how we present ourselves to the world. If we show off what we make too many times, and talk up the work we produce, others may only see our ego and ignore the quality of our actual work. But conversely, never sharing our work, or not accepting compliments for it, can be a mirror into the fears that we hold, or our low self-esteem.

IDENTITY AND SELF-WORTH

Our sense of personal identity can be wound up in what we make, and how we make. Which of course means it may be hard to show this work to the world and be open to hearing the compliments as well as the criticism it may incite. Learning to let go of worries about how our creative work is perceived can guide us along the journey of learning to be less concerned about

how we are personally perceived in the world. Instead of over-thinking what everyone we have ever met might be whispering about us, we can step through the gossip with a sense of self-worth and acceptance of who we are. Rather than tying our own image of ourselves to other people's expectations or perceptions, we are able to feel steady in how we fit into society.

MAKING WITH TRUTH TO OURSELVES

When we feel in tune with what we are making, it is often easier to share our work and be less attached to what other people may think of it. If our work feels like it comes from a place of intention – when we have sat mindfully with our making – it feels more solidly representational of 'self'. Instead of impressing our fears or weaknesses onto our work, we can find a way to simply make things that feel right to us. The more we can tap into that feeling, when our making is a process or product connecting with our internal self, the more we feel a connection to what we make.

Finding these internal expressions of who we are and bringing them to the light may make us feel vulnerable – and sharing this work with others can seem scary or hard. But when we love something that we put into the world, simply for the sake of loving it wholly, it seems to matter less what others say about it. In the same way that a mother loves her child regardless of its beauty (in society's standards), so we can love our work because it has come from a mindful connection. Our ego doesn't need to be crushed because someone else doesn't love our child. We might simply decide that person isn't the right person for us to share our work with, and we will better understand that we are all different, with unique likes, dislikes and experiences.

If we make our work for the purpose of pleasing someone else – perhaps to have our egos stroked, or to boost our online status – this often means that we are making work that doesn't feel true to ourselves. When we do not tap into our internal quiet, and instead are only guided by the noise of the world, we lose a vital

connection between our making and our self. Making becomes a mindless activity.

It can be a hard lesson, but if everything we do in life is done simply to appease or appeal to someone else, then we are neglecting our own needs and wants, and downplaying our importance in the world. By mindfully approaching how our ego shows up in what we make, and how we are guided to make what we make, we are able to gain a better understanding of our personality, of how we fit into our communities and society, and of how we see ourselves within the world.

Being Conscious
of the
Environment

Once you start to tap into your surroundings, through mindful observation, the world around you can become even more special and meaningful, and you might start to ponder the effects and impact of your making on the very environment that is so inspirational to you.

I once read a quilter's quote, 'She who dies with the most fabric wins', and it shocked me into looking more closely at my own stash of supplies. Being a maker brings with it many fun adventures visiting art or craft shops, and a huge

amount of new materials and supplies. Once we start stocking our shelves with all the things we (think we) need for our making journey, it can become a long list of 'must haves', and our shelves can get full to overflowing. Being a mindful maker can lead us into becoming more environmentally conscious about what supplies we bring into our studios or work spaces. It seems counterintuitive to look to nature for inspiration and yet to make something that clutters or destroys it.

CHOOSING YOUR MATERIALS WISELY

Caring for your garden, your neighbourhood or the wider environment doesn't have to mean that you forgo using all materials in your making or lose the joy of making entirely. It can simply mean a new way of looking at things, a shift in your perspective to see how different materials, supplies or methods could work instead of the ones that you are used to using.

Many potters and ceramicists are opting to dig their own clay or find supplies that access local clays, in order

to minimize the disruption to other environments and think about their own nearby earth (clay) in a new way. Using low-toxic glazes adds to the story of their work, while staying thoughtful to their surroundings. Natural dyers can use local plants and flowers to create beautiful colours from nature – a shift away from the harsh chemicals that have been prevalent since the first modern synthetic dye was created in 1856. Looking back to how our ancestors created colour, adorning their bodies and homes while also respecting the environment, can give us inspiration to make and create mindfully, in harmony with the Earth.

Researching where our materials come from, who made them and how they arrived at our doorsteps is the start of a change, enabling us to join a revolution of makers who choose their materials wisely, not based on mindless wants and needs, but with a deeper connection to the environment, humanity and our own personal stories of how we fit into our world. It might mean giving up some aspects of what we are used to

working with, but it also opens a door to a more meaningful relationship with our things.

THE MINDFULNESS OF 'STUFF'

The angst of making more 'stuff' in a world already overflowing with things is something that hits me at times. Being a maker means that my hands use materials and resources to create something that contributes to the world. As a mindful maker, I ponder each item and its end use in our environment and our society. I don't want to make things that simply pile up on top of other things, layers of unnecessary stuff which some may call art, others simply junk.

By starting out using materials chosen for their low environmental impact – natural fibres versus synthetic materials, or local, natural dyes compared to chemical dyes – we have already thought about the final life stage of our works. Simple shifts in how we make and what materials we use means that any 'stuff' we make can be composted rather than adding to mountains of landfill.

Balancing our internal desire to make things against our environmental ethos of not overwhelming an already overloaded planet, means that when we sit to make something we think deeply about what it may become, who might need or use it, or how much joy or pleasure it will bring to us (the maker) and someone else (the viewer or recipient).

A makers' community creates handmade things that have more meaning than those manufactured by a mass-produced society. By taking time, as makers, to create our works, we guide our audience and community to slow down in their mindless consumption of things, and help them to see that one beautiful handmade item might be more vital than ten or a hundred mass-made things. This is true for clothing, artwork, bowls or cups, rugs, ornaments, pictures, furniture or anything we make with our hands. Being mindful in our making of things can encourage our society to slow down in its consumption of stuff, and so help protect the fragile, precious world around us.

Learning
Slowly &
Patiently

Many young makers or creatives seem to want to be experts straight away, without the time, practice and energy involved in learning the art of the craft. Being thoughtful in our approach to making, however, will guide us along a slower journey towards learning how to make more mindfully. A master takes years to learn the skill of their profession, with countless hours invested into understanding the techniques and nuances of their craft.

Finding a simple joy in our making comes not from rushing the outcome or result, but from taking time to

patiently learn how to feel our work in ourselves, to respect the process and honour the craft. The speed with which the world seems to move, with people expecting answers straight away, means that we feel frustrated if it takes time to learn a new skill or process. Some schools of thought say that we have not truly mastered a new skill until we have invested at least 10,000 hours in learning it.

FOCUS ON THE PRESENT MOMENT

Rather than constantly looking ahead and counting down time, it is more beneficial to settle into the spot where you are and be content to simply keep on making. Learning or practising our new skill comes from the day-to-day making, the hard work of trying and practising and failing and learning. Slowing down our breathing and feeling settled in our place, here and now, means that we are more focused on our work in our hands, deeply immersed in the practice of making. The pleasure of learning a new skill comes from being

fully invested in where we are, not looking to the finished result or aiming for the perfection of someone else's work.

LEARNING AND LOVING YOUR CRAFT

Slow learning means slow living. Feeling the weight of our materials in our hands grounds us, and connects us with our making on a deeper level. Learning and feeling the slow, long burn of loving your makes builds up gradually over time; it seems the more we breathe into our work the more it feels personally connected to us. This leads to a much more intense relationship with what and how we make, rather than a quickly popped bubble of excitement.

In our fast-paced world, there is a depth that is hard to describe related to knowing our craft on a very intimate level. Having hands plunged into clay or wrapped with fibre or yarn for weeks upon weeks, or learning the intricacies of metals to create jewellery,

means that we have the true essence of our work etched into our hands, the weight and feel of it ingrained in our fingers. We are giving ourselves time to really know our work, our tools, our materials, and to fully converse with them.

By giving our materials and tools the focus they deserve through slow and patient learning, we are able to have a better conversation with them, a long-lasting friendship that will allow us to learn the truth of what they are capable of in our hands. The quick lessons are often forgotten, while those that take us time to really learn, and put into practice, are forever ingrained in our mind or our hands. Dipping in and out of quick crafts, while sometimes fun, can mean that we miss out on the true learning that's involved in the long, slow burn of any skill. A sewer who gives time and patience to the practice of techniques better understands how they can avoid mishaps, create better shape or use their materials in a more beneficial way. A woodworker needs many hours or years of dedication to their craft to learn how

wood feels and moves under tools, how to get the best from the quality of wood, and how to make it sing in their hands.

INSIGHT THROUGH SLOWNESS

Learning something slowly and taking time to make something means we have a deeper understanding of how it works, and why it feels good for us. So it is in life, too, where by slowing down we can invest more time and patience into understanding other people or experiences different to our own. A gentler approach may give us an insight that rushing never could.

Some things cannot be easily rushed, in the maker world, and while we don't all need to aim for the perfection of a master, we can remember to slow down into our making as a way to enhance our technique, to better know what is possible within our hands – and to teach us, too, to slow down into the possibilities of our wider life, to perhaps see things as they really are, not as we assume they must be.

Working in
the Flow

For me to find the real truth and rawness in my
personal creative work, I need to find some solitude
and reach inside myself; to stop talking about what
I should do, and start having a conversation with what
is happening in my artwork; to stop trying to dictate
the outcome, but instead allow the process to flow and
the piece to almost work itself.

Hungarian-American psychology professor Mihaly
Csikszentmihalyi talks about 'flow' as a state of
complete absorption in the current creative or artistic
experience. Being in a state of flow while you are
making means you are so deeply immersed in what you
are doing that you lose track of time or what is around

you. You are so caught up in the joy and excitement of your making that you fall into something similar to a meditative state of mind. This is something that most makers experience at some stage during their making life, and try to regain again and again.

When you are in a state of flow, you know it. For me, I have a not-quite-fuzzy feeling in my brain, where the world is a bit blurry but I am seeing things in a super-clear way, as if with a different part of my brain. Rather than over-analysing everything, I am simply observing things and letting them flow and evolve, my mind and hands working together effortlessly. What results from working in the state of flow, in my personal experience, is something that feels deeply 'me' and resonates with my thoughts and soul, while also showcasing my skills as a maker.

FINDING YOUR FLOW

It is not always easy to slip into a state of flow as quickly or as often as we would like, but it is something

that we can work on and better understand as we continue our practice. Flow is easiest to find when there is a balance between the level of our skills and the challenge of our project; if we are trying too hard to learn, or are bored in our making, a state of flow is less likely to be experienced.

By giving ourselves the quiet that we need, flow comes a little easier than if external forces (or indeed our own persistence) keep demanding it. Flow can be elusive when we insist that it arrive and stay. Putting external diversions and distractions far away from us also helps to encourage flow, while dedicating time to our project means we can develop a better relationship with understanding how and when flow might work for us. Space, quietness and dedication to practice all seem to be integral, as well as respect for our work. By finding flow, we come upon a state of joy and happiness that seems to mean almost anything we make with our hands is quite beautiful indeed – even if only in the eye of the beholder!

WORKING THROUGH BLOCKS

For every period of flow we experience, we are likely also to come across its antithesis – the creative block. Understanding that creative blocks are one of the things we must endure as makers, gives us a little more patience when they arrive. By looking at where and how we react to such blocks, we are better able to understand ourselves and how we present ourselves in the world when challenges arise. Looking objectively at what is stopping our creative flow sometimes helps, while also giving us insight into who we are as people in the world.

Rather than always seeking the ecstasy of creative flow, and feeling pent-up when blocks challenge us, it is helpful to see both as they are, and to understand how we can create changes to each by our response. Getting angry when encountering a creative block only appears to make it stay around longer, while trying to force flow seems to make it slip from our grasp. Simply 'being', and not trying so hard, seem to be the best way to move

out of a creative block into a state of flow. Letting our body relax, our breath soften and our hands do what they long for, releases anxiety or tension from our body, meaning our mind is better able to move about freely and gently, with focus and clarity.

Working in a state of flow, we often find we spend less time judging our work, which spills out into our wider lives as well. The effect of contentment in our creative work leads us to feel a deeper sense of happiness in our lives, where we are not overthinking or second-guessing all our actions. Working less from fear, and more from the internal sense of flow, means that when we step out of the studio we feel more at ease with ourselves in the world.

Nature
– the Greatest Muse

As a maker, how often do you step outside and look about you, to find inspiration from the greatest muse of all? 'Inspiration' means the act of drawing something into you, specifically the drawing of air into lungs. Being in nature seems to be one of the best places to find inspiration for our making, allowing us to breathe in the colours, textures and smells of the outside world, and fresh oxygen to replenish our brains.

Actively spending time outside in nature helps to slow us down and notice the minute details of life, the slow changing of the seasons, the beauty in simple everyday things – an unfurling flower, clouds scudding across a cerulean sky, a bird singing, the dusting of snow

on a branch. Teaching ourselves to look and truly see
different aspects of nature helps us to be part of our
environment more fully, and guides us to slow our days
down so that we can enjoy these moments for longer
and more often. Learning to settle happily, contentedly,
into the quiet of your garden, a local park, a nearby
forest or even just your balcony in order to soak up the
inspiration means that you are doing less seeking in the
noisy world, and more being in the real world.

MINDFUL MOMENTS IN NATURE

Building time in nature into our week, or better yet into
our day's routine, means we are actively choosing how
we experience the world around us. Not rushing
through it, nor simply stopping to smell the roses, but
going deeper still. Looking past the obvious beauty of
the roses and taking in all aspects of nature shows us
that beauty can also exist in decay, in the mundane – a
fallen leaf, a dying flower, a broken cobweb – and in the
ignored aspects of our life. When your eyes are opened

to seeing and experiencing the subtle intricacies of beauty in nature around you, you naturally slow into a more mindful process of being in the world.

Some years back I visited a big city for a week, and during that time didn't touch my bare feet onto the earth. I felt tensions build up in my body, as I walked upon built pathways, paved streets and a fenced-in backyard. Upon returning back to my rainforest home I removed my shoes and immediately felt the connection with Earth return, and my heart rate slowed a little from the frantic pace of the city.

'Shinrin-yoku' is a Japanese term, which loosely translates to 'forest bathing' or 'taking in the forest atmosphere'. This practice, of spending time in the forest to promote health and wellbeing, developed in Japan in the 1980s, during a time where it seems our human instincts had forgotten the deep connection we need with the Earth in order to stay healthy, mindful and live a low-stress life. Simply being outside in nature increases our energy levels and happiness, and helps

improve our sleep – all things we need to prioritize in our ever-expanding concrete world.

TAKING YOUR CREATIVE WORK OUTSIDE

Taking our making work outside can be one of the most peaceful ways to experience a slower pace of life, combining the connectedness with Earth and the meaningfulness of using our hands. A hand-sewing kit, an outdoor hand-built kiln, a space for wood shavings to scatter, painting or sketching en plein air, taking castings for jewellery work – it doesn't matter what you do; if you are able to step outside to continue your work, you will find it highly beneficial. Using portable hand tools allows you the joy and freedom of working outdoors and is also a great way to create a quieter space for your making without the background whirr of machinery. Inspiration from nature can show up in our work in many ways, but using natural materials directly from our surrounding environment, such as

leaves, clay, flowers or wood, connects us while sharing our story of where or how we fit in our own landscapes.

Of course, it is not always practical to take our materials and tools outside, but by aiming to create a space to work and indeed to live in a way that connects deeper with nature means that every day we have more of a chance of experiencing the benefits of 'forest bathing'. It could be filling a corner of your work space and home with potted plants, or opening the windows wider, or planting out a window box. In our modern world of built environments, small changes can help create pockets of mindfulness within our lives.

Mono-tasking

Often it seems that society, and particularly the mainstream media, is intent on rushing us into ever more jobs and activities, glorifying 'busy' and making multi-tasking a skill we all must possess. Yet research, and indeed simple self-exploration, reminds us that all multi-tasking does is simply make us do more things with less intention.

It seems the human brain cannot do two activities at once, so rather than actually multi-tasking what we end up doing is 'task switching' – very quickly swapping from one thing to another. This means we are forever catching up and reminding ourselves of where we are up to, and what we are meant to be doing. When we

try to multi-task we actually do numerous tasks ineffectually, rather than doing one task very well.

As well as not allowing us to complete tasks to the best possible ability, multi-tasking also makes us stressed and may lead to our brains having a shorter attention span than our ancestors, so that we are forever jumping from task to task wanting the next fun moment, rather than following a task through to the end and completing something fully. By focusing and allowing our minds to mono-task, or settle on one task at a time, we can immerse deeper into the project in front of us, giving it our full attention and intention.

RETRAINING OUR MINDS

It may require a retraining of how you work, or make, but by choosing mono-tasking in your practice you may find that you have better focus, and a better outcome – whether in your creative work or in other aspects of your life. Practising mono-tasking in our creative making begins the process of learning to settle our

minds on one project at a time. Becoming immersed in the work our hands are doing gives our mind space to focus, and to dedicate attention or intention to what we are creating.

Rather than trying to work on more than one project at a time, mono-tasking requires that we actively choose just one thing, and put aside all other interruptions. This trains our brains to slow down, and not always look for the easy way out. Our brains may become bored, mindlessly searching about for a new shiny thing to entertain us, and they may try to trick us into doing multiple things, but it is up to us to guide ourselves back to the moment, with the simple act of using our hands to dedicate to one thing at a time.

Putting our phone on silent, ignoring incoming emails and resisting the pull of scrolling through our phones or devices, means that we slowly take control of our external environment, rather than allowing it to dictate what and when or how we make something. Gathering our tools and materials before we begin,

and having our space set up for making, means that we can settle into being fully where we are, without constantly wandering off to pick up something we need, and then getting distracted along the way.

MASTERY AND FOCUS

We may find, through mono-tasking, that we get closer to perfection, or mastering a skill, by giving the project our full mind focus, not shifting here and there. A jeweller who makes a whole batch of earrings may find that mono-tasking allows for better shape, perfection in technique, and results in outcome, than trying to make earrings while also taking photographs and searching for new supplies online.

Mono-tasking means that we sit with our work, and push through any challenges, rather than finding an excuse to flit to another project. Perhaps your knitting is getting tricky, so you put the project away and pick up another knit to work on. Or maybe the teapot shape you are trying to throw isn't working out, so you tidy

your studio instead, or switch to hand building. While this process can give our brains time to settle from any frustrations in our making, it is also teaching us that it is okay to drop the harder things in life and move onto something easier or more immediately fulfilling. If we never plough through to the end of a project and are always seeking a different stimulus in our making, we are giving ourselves permission to do this in life, too. If a conversation becomes a little boring, or the work we are doing isn't getting where we expected it to immediately, we allow ourselves to open a new tab on our browser, or check our social media or emails again.

In an overbusy society of information overload, we can guide ourselves on a slower journey by ignoring those temptations for a quick fix, and staying focused on our project at hand. Completing one thing well, rather than having five half-finished projects, shows us the joyful contentment we can feel at setting our intentions to work through to the end.

Making
Mistakes

Being a maker often brings up parts of our work where things go a bit wonky – perhaps we accidentally skip a stitch or two in our knitting project, or our thread becomes knotted and tangled under our sewing needle. This is the chance to sit up and pull our work back and recognize that not everything in life always works out. It's a very immediate reminder that even if we are intently focused on our work, mistakes can happen.

Mistakes are often thought of as bad or wrong, or at the very least that one must 'learn the lesson' of the mistake that you have made. But how would it be if we could let go of the idea of perfection and 'never making a mistake', and instead allow our mistakes to guide us in

a new direction as makers, and in a wider sense along our life's journey?

A CHANCE TO PAUSE

Mistakes often happen when we are being mindless, perhaps not counting stitches or watching our process as it occurs. This mindlessness shows itself in our personalities, too, as we rush about following along a path, without stopping to look where we are, or where we might be going.

I first started sewing on a machine many years ago, and would be frustrated every time I made a mistake and had to use the quick unpick to pull back my stitches. But over time, and learning to approach life in a different way, I started to recognize that making a mistake allowed me the space to create change. At this point I could either continue on and become frustrated, or I could mindfully pay more attention to my work. The very gentle reminder of needing to unpick knotted threads gives us the opportunity to straighten our backs,

breathe in deeply, and be grateful for a moment to pause in our work, to reassess it and our approach to what we are making.

UNRAVELLING OUR MISTAKES

In a much bigger sense, the chance to unpick our work is a reminder about how we live our lives. We can learn that going backwards to where we began is not a bad thing. It doesn't indicate failure but gives us the ability to look at things with new eyes, to send us in new directions. Life does not have to always be about moving forward and reaching a goal, but can just as easily be about standing still and looking at where we are right here and now.

In life sometimes we say or do the wrong things, and rather than simply pushing on, trying to cover up the problems or ignoring our mistakes, we need to create the chance to look at our actions, which can lead to the breaking down of any walls or barriers we may put up, both in our creative practice and in our relationships.

By having the space to change ourselves or alter our life, we can become mindful in the path we follow as humans upon this Earth. Each step, or stitch, can be chosen with more care in future.

Tugging at the threads of our work is symbolic of tugging at our life, looking back at past regrets and allowing them to fall away, as we unpick or pull apart our creative work. To start with the raw materials and create again, is a reminder that each day is a chance to mindfully re-work ourselves. Just as the raw materials are often marked with the previous project (such as yarn that's bumpy and curly, canvas that's marked up or clay that needs re-kneading), so also is our life already marked with our past experiences, loves, losses, heartbreak and joy.

LIVING WITH OUR MISTAKES

Of course, not all mistakes can be pulled back and fixed. Some mistakes, in life and in our creative practice, are there to stay, and we must find a way to work and live

with those mistakes, to continue being gentle with ourselves in our work and as humans learning this path of how to live more gracefully. By learning to accept mistakes in our work, we learn a peace with our creative making. The frustration at it being 'wrong' dissipates and fades. Our mindset can shift dramatically when we view the mistake as valuable rather than as something wrong. When we are able to see the beauty of an artistic mistake, it can show us the potential of forgiving everyday mistakes, and seeing them not as a fault of character but more as a journey of living and learning.

Centring Ourselves

Some days life feels so busy and full that we ask ourselves, is time slipping away from us? As a society, we are spending more of our days rushing around filling up time. Studies suggest that we aren't working any more hours than our ancestors, and in fact we may even have more leisure time than they did, but our constant access to information via technology and our state of always 'being on' means that we have less quiet time than ever before.

It seems being busy is a status symbol, representing how in demand and important we are, with constant emails, social media alerts, phone calls and to-do lists. We let technology dictate our schedule, and as a result

feel more overwhelmed, stressed and anxious, and busier than ever. This can lead to us living a whirlwind life where we are constantly pulled in every direction, and forget how to balance ourselves, to find our centre and come back to our own internal inspirations.

FINDING THE INNER QUIET

Centring ourselves is necessary for some crafts, especially wheel throwing. Recently I joined a local pottery class, and was quickly reminded that if you want to throw a pot of any sort, you need to be centred. Every act of sitting at a pottery wheel guides you towards the finished pot. If you're not sitting straight and relaxed, your pot will be wonky. If you haven't thrown the clay directly in the centre of the wheel, your pot will have little chance of forming. If you've brought turmoil and stress from the outside world to your wheel, it will take longer for you to centre the clay. The technique of centring a piece of clay comes from deep within yourself.

Some days I sat at the wheel and found it exceedingly difficult to get the clay doing what I wanted. The more I tried, the harder it was, and the wonkier it all went. While practice (and more practice) of course comes into play with many creative outlets, particularly ceramics, it was the centring in my own mind and body that made the difference between being able to create a pot or not. I am happy to report I eventually came home with a very small handful of unique pots – most a little wonky – but more importantly I was reminded again of the very real importance of finding the centre in yourself and working outwards from that.

HOW TO FIND YOUR CENTRE

Centring ourselves comes from our breathing and our mindful connection to the present moment, consciously noticing ourselves being in the here and now. The practice of yoga or even slow mindful walking brings us to our centre, by focusing on our physical core and slowing our breathing. Visualizing an inner quiet helps

us to find our centre, too. Balancing ourselves on our two feet or sitting squarely at the potter's wheel allows us to feel the centre of gravity in our bodies. The everyday rush of life, in which we rarely stop to check in with how our bodies are feeling, means that we cannot easily determine if we are off-balance or not. By physically stilling our bodies we give ourselves the moments needed to discover or reconnect with our own heartbeat, to feel and hear what is going on around us.

FORMING THE HABIT

Sometimes it is the doing of the work that brings the centring, the pushing through and keeping on trying, the learning to relax into the making. After a time of being in the process we find our centre, we find our slow mind again. But sometimes it is the lessons from the last studio session that come back to us before we begin making again, enabling us to work with a little more insight. Having the feeling of relaxed centring before we even begin our work seems to put us a step

ahead in creating something of balance and ease. When we learn to settle the noise and turmoil of the outside world before we even sit down at our workspace, we can then spend more time immersed in the quiet flow, and less time battling through to find the quiet.

Simple reminders to breathe and settle our minds come to us with practice, along with the rhythm of our own particular routines – a balance of remembering, learning and practising as we go along our maker's journey. The simple act of centring ourselves brings a calm to our minds and bodies that can help to make us more resilient to the rush of modern life.

Motivations
for
Making

Why do we make? Sometimes we make things for the simple pleasure of making something, or because we need or want a particular item in our life. Other times we make for the purpose of sharing our voice in the world. We want to express ourselves and our personality through our making.

SELF-EXPRESSION THROUGH MAKING

Being a maker doesn't necessarily imply that you are an artist or that you want to always share your internal dialogue, but your making and how you approach it can

say a lot about you. And it can be a way to let your ideas or ideals be better viewed by others. When you make something, such as an item of clothing, that is easier and cheaper to buy from a shop than it is to make yourself, what you are saying – sometimes in a roundabout way, sometimes more obviously – is that you value things made by hand. You value the quality of what you wear, and what you own. You value other people in the world who may be being paid low wages to produce the mass-produced items you are choosing not to buy. You value the intentional, mindful time you spend on making compared to the consumerist habits of mindless shopping. You value wearing your unique outfits when others might choose the sameness of the latest mass-market fashion.

Your choice of fabric or materials says something about your ethics or ethos. Using a fabric produced sustainably says more about who you are than you might imagine. Actively seeking out materials for your making that are made thoughtfully, environmentally

and locally, is – sometimes quietly – telling the world that those things matter to you.

Our making life can be a representation of us as humans in the world. Choosing to make things when almost anything and everything nowadays can be purchased, is a way of stating what we value, and how we want to live. The way that we intentionally pick up a tool and use it says a lot about our personalities, opinions and outlook on life.

Some makers, or tinkerers, have a way with fixing and re-using materials in their projects. By taking someone else's junk and turning it into a new item, we are being mindful of the world we live in and the ever-increasing environmental issue of human waste. Developing resourcefulness as a maker, by using the materials we already have, changes our thought processes for how we can engage in the world. Being inspired by stories of lost or thrown-away items may ignite our curiosity towards the quiet stories of other people, and guide us towards seeing them in a new light.

SELF-KNOWLEDGE THROUGH MAKING

Our daily process of making can be seen as a visual plan of how we see ourselves in the world. Do we perhaps sit back and watch, not making much at all, but watching other people create things and wishing we could step up and find our place in the making realm? Are we a maker who follows trends and wants to share only the best of what we make? Or are we happy to talk about our mistakes, the almost perfect pieces that broke or failed at the last minute? None are worse or better than another; they are simply different ways of approaching a project, and indeed life. But sometimes it is easier to examine ourselves as makers than to dissect ourselves in our wider lives. Choosing to change directions in your making process can create change in your daily life, if you so desire, to push through the challenges, and create new ways of seeing and being.

Understanding what propels you to make can be a way to better understand your motivations in life.

Are you making for making's sake, or because the value of your time invested in creating something of purpose feels important? Are you choosing your materials wisely, or simply picking up whatever happens to be in front of you at the time? Do you make the same thing over and over again, as a way of problem-solving and finding a different outcome? Are you making as a way to understand yourself better, or as a way to step off the whirlwind of society's carousel?

Spending a little time looking deeper at your motivation for making may help guide you to a more intentional purpose behind your makes. Rather than continuing on in life, or in your studio, out of habit, you can choose to move forwards with a purpose that comes from mindfulness and conscious decision.

The Monotony
of Making

Happiness is such a bright and bubbly word, and something many of us aim for in our making and our everyday lives. But is it really necessary to seek, or create, happiness in every single moment? Can we appreciate the boring and mundane moments as much as the joyful times?

During the journey of a project we come across exciting moments, where we are overflowing with ideas, but equally there are many times where we are simply following a routine, doing the same process over and over again. Throwing clay on a wheel or knitting stitch after stitch can become monotonous after some hours, or days, or years of working with the same technique.

FINDING MINDFULNESS IN MONOTONY

Being a maker is not always exciting. Often there is a lot of doing and re-doing, again and again, getting things right, trying and re-trying, making mistakes, learning and re-learning. The process is slow and sometimes it can be tedious. It is not all about a creative spark, a thrilling bolt of inspiration. More time is spent in the quiet depths of not knowing what the outcome of a piece of work will be, or if indeed it will even progress to a finished piece. Some projects involve so much tedium in the making process that it feels difficult to keep going.

Yet, it is often in those moments of boredom and monotony that we find our deeper connection with ourselves. The mundane moments of our projects bring about the space to seek and hear our internal voices, to find a place of quiet contemplation. The meditation in the practice is what comes out of settling into the monotone rhythm of your work.

At my weaving loom, I find that making stitch upon stitch, with the texture of the yarn in my fingers, creates a deep sense of contentment and state of flow, and allows me to move beyond the mechanics of the process of making, and step into a different realm of my creative self. I am able to transcend the conversations with my yarns and colours and weaving loom, into a space where I can connect deeply with my emotions, listen into the environment and sounds around me, yet not be drawn into them or settle upon them. Despite the slight pain in my legs when I am sitting still for so long, I do not feel compelled to move or wiggle about. I find myself in a space where time does not exist, and I don't think about how much more time I might have until I am interrupted or must put down my tools.

While not true meditation, this for me is the start of creating space in my brain where the noise of the world flows past me, and I don't feel the need to connect to it or hold onto it. I move past my own self, stop listening to my own internal stories, or expectations, or ideas of

what might happen or not happen with my work –
or indeed my life. When I am just sitting with the
monotonous moments of my making, I find that I
become the most mindfully aware I can be. Thoughts
flow through me; I don't dictate them, or force them,
but simply allow them to move on and through.

PUSHING THROUGH BOREDOM

For someone new to a skill or project, finding mindful
awareness in the monotony of making can be very hard,
because we are so often focused on learning the
technique and working through the mistake-making
phase. But when we are able to notice our levels of
boredom, and observe the times that we give up because
things are too frustrating, we can understand that these
are the times we need to push through. As a maker, our
work will benefit a thousandfold by not giving up, by
keeping on showing up and being there. In our making
practice, as in life, difficult or boring things come upon
us, and our response to these challenges shows us our

personalities, while opening our minds towards ways we can slowly change ourselves. If we are always seeking the pleasant and easy aspects of our making, are we also teaching ourselves to avoid challenges in life?

Our practice of finding quietness in the monotony of our work will guide us along a journey of contentment, in which we can find joy in the mundane moments of life. If we can settle happily with the simple things, we will find they become necessary and beautiful, and the shiny, exciting things that drag us away from our inner selves can fall aside. We can train ourselves to seek and enjoy the rough texture of an ordinary life, finding contentment in small, simple moments of creative work and everyday living.

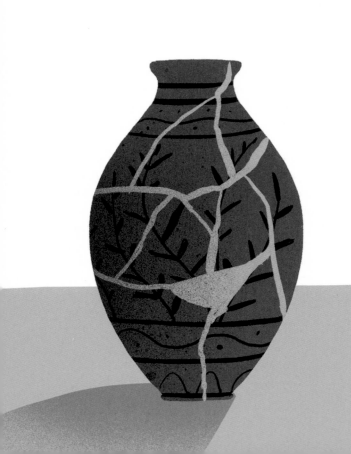

Repairing
the Broken

Things break, in life and in our work, and finding a way to navigate this despair can be part of our journey towards a gentler life, giving us an understanding of non-attachment, and an appreciation of the lessons that come from all challenges. A hurt friendship or broken pot – both bring about a sense of sadness and give us the opportunity to repair the emotional damage, as well as any physical cracks. It is humbling to observe the broken parts of life and work through how we can fix them, but it does take a new way of looking, with a gentleness that sometimes takes years to learn or understand, and longer still to know how to share with others. How we deal with a breakage in the things that

we make can show deeply how we can deal with
challenges in our wider lives.

KEEPING CALM

Non-attachment towards material things is a lesson I
learn each time a special cup or pottery vessel is broken.
When I was younger I might rage and cry, or yell at the
person who broke it, whereas now I can stop for a
moment and realize that I still have the memories of
that item, and the breaking of it cannot take those away.
As I gathered up a broken vase recently that I had hand
built when I was a teenager, rather than getting mad at
my child for being the catalyst for it being knocked off
the shelf, I took the opportunity to joyfully remember
the days when I made it.

Stopping ourselves from taking immediate action
when something doesn't go right is a lesson to always
keep learning. It allows us to think clearly before we
speak in certain situations in life, and means we are
often gentler on those around us, and on ourselves also.

Getting upset rarely solves a problem, but taking a gentle approach means we have more time to assess how others are feeling and to listen to our own feelings.

THE GOLDEN MOMENTS

Sometimes magic comes from the broken moments – when your paper tears apart, your wood splits or your silverwork breaks. At first, frustration builds when we come across such times of difficulty in our projects, but when we look at things in a new light we can find the golden moments. To repair the damaged paper, split wood or broken metals means to re-examine our tools or materials, teaching us to use what we have and make do with what is to hand. Sewing the paper, gluing the wood, soldering the metals together gives our work an extra depth, where the damage is not hidden but becomes part of the piece, like a scar upon our face or body that tells a story of our past pains and experiences.

When something breaks we have the choice of how to deal with it: we can either throw it away, honouring

the memories of making it, or we can repair it. Neither is necessarily better than the other, but by looking slowly and mindfully at the damage, we are able to assess what feels right for that situation. So it is in life, too. Sometimes it is best to let a friendship go, not holding onto the anger or pain, but smiling at what you had, whereas other times it is okay to mend the hurt and help each other to heal, while knowing that there is a fragility that needs to be honoured in everyday life and not taken for granted.

Kintsugi, meaning 'golden joinery', is the Japanese art of repairing broken pottery with golden lacquer. Also known as kintsukuroi (or 'golden repair'), the practice is based on a philosophy that treats the broken parts and the subsequent repair work as part of the history of the vessel. Rather than hiding or trying to disguise the damage, kintsugi highlights it with golden work. The practice teaches us about non-attachment to our work, about appreciating what was, and about allowing something of use to continue to have a life, rather than

simply being discarded. It also encourages us to take care of the new work, the gold being a symbol of how we choose to save a friendship or relationship, and know to be gentle with each other in future.

The absolute beauty of a piece of ceramic repaired in this manner shows how profoundly important it is to honour the broken aspects of our work, to take a mindful moment before frustration forces us to throw it out. Instead, we should look at our torn fabric, broken metals, shattered wood or imperfect pieces, and find the gold with which to evolve our work to a different level.

The Seasons
of our
Creative Life

Unless you are a full-time maker, with no family, study, work or external commitments, the time that you can dedicate to your making is often pulled away. Tendrils of our life demand our attention, from work deadlines to study projects or the everyday hum of family life. Some days we are endlessly torn between what we need to be doing and what we want to be doing, and this can mean we are always looking ahead waiting for the perfect moment to begin something that our heart sings to make. It is up to us to find the way to make a balance work in our hearts so we don't feel frustrated.

Parenting is one area of our lives where finding the balance can be especially hard. In my creative life I draw upon my experiences as a mother, and allow it to show up in my work. But sometimes parenting and finding space for making can appear to be completely at odds with each other, and it feels like we must choose one or the other. The balance that we hear others talk about seems elusive to grasp and bring into our lives at the best of times, but when we are talking about parenting and making at the same time it feels almost impossible. While both are joyful aspects of who we are, sometimes there is an internal divide between parent and maker, and trying to find space in our hearts and minds can be a lifelong juggle.

A TIME FOR EVERYTHING

In my experience the life balance that many talk about, or seek, does not really exist. Rather than trying to multi-task all our roles, for instance, parent, partner, income-earner and maker, we would do better to

recognize the ebb and flow of life and settle more contentedly into one role or another at different times. Realizing that balance is not truly sustainable gives us some peace, and allows our constant chasing to keep up with everything to slip away. Aiming for a perfect balance in life leads only to anxiety and stress.

Rather, I have found that allowing some aspects of my life to be more visible while others wait quietly is the best, perhaps only, way to 'do it all'. I like to think of my life as seasonal, where things ebb and flow. I don't rush or force things, but allow them to happen naturally. Unlike a true cyclic season in our gardens, the seasons of our creative life can come in different bursts. While a creative summer is blossoming and overflowing, it might coincide with an easing off – the winter – of another aspect of our life. By giving fully to the rhythm of the seasons, we are able to experience the fullness of summer, while not feeling guilty that the depths of winter have overtaken another aspect of our life. The seasons of daily life mean that summer and

winter could fall within hours of each other, but when we can notice the differences we are able to immerse ourselves fully in one and not look longingly for the other. Knowing that the summer of our making time will come again, we can experience a more mindful time in our other roles, as parents, partners or workers.

BEING IN THE HERE AND NOW

The nature of making is often, by its very nature, up and down. Ideas burst forth at an astounding rate, like springtime after a long quiet winter, and then just as easily they'll slip away, falling like the autumn leaves. True mindfulness in our creative lives means that we understand these variances, and allow them, without feeling lost when our ideas fall apart or disappear altogether. Instead, we can focus on another aspect of our lives – take up the summer of parenting for example, or immerse ourselves deeply into the joy of being fully present with our work, study or any other aspects of our lives.

To find a way to be fully here and now, not looking always to future dreams or longings, is part of the challenge of being present and mindful. This is a journey where we have the opportunity to grow each day, finding ways to change and discover different techniques and processes that might suit our family, work or study life best. It can change our outlook on our whole life. Rather than endlessly wanting to be somewhere else or someone else, we can stop and appreciate where we are right now. Our seasons of self will continue to flow; it is up to us to enjoy being fully present in each stage.

Finding Solace
in your Making

Some days life can be hard, and finding our way through our emotions can be draining, but immersing ourselves in the work that our hands can do can be very satisfying. Emotionally and physically, the process of making gives us a chance to slow down and step away from the turmoil and stress of life. Using our hands for meaningful, mindful purpose gives our pent-up feelings and emotions a healing outlet. By physically slowing our bodies down in order to sit down and make something with our hands, we are taking the first step towards allowing ourselves to process any grief or hardships that we might be experiencing. If we take the time to focus on our difficult thoughts, rather than

rushing around trying to outrun them, we give ourselves the chance to heal, through our crafts, our hands and our practice of making.

CRAFT AS HEALING

Modern society is overcome with stress and anxiety, and it is hard to step outside our busy lives for long enough to recognize that we too are feeling overwhelmed by our to-do lists and our keeping up with appearances, by our efforts to stay on track with living the fullness of life that we aspire to. It sometimes seems easier to not face our stress, to push it away, but that only contributes to making it worse, leaving us even sicker.

By scheduling the time and space for making into our days, even just once a week, we are giving ourselves permission to seek the quiet that we so desperately need yet often don't even realize we're longing for. Making a cup of coffee, gathering the supplies needed and settling down for a small moment of making gives space for our busy brains to stop whirling for a minute,

and concentrate on other things. The healing that can begin is something you might not even realize you needed, but by beginning a project, by using your hands in a new way, you will soon find that you can find true solace in your making – both from the actual process of making, and from the times in between that you spend thinking about it. A new project, or the continuation of a long-term project, gives us something tangible to work through, to problem solve, to ponder. Rather than overthinking the dramas of our daily lives, we can focus instead on finding inspiration for our projects.

REFLECTION AND CONNECTION

Not so many generations ago, our ancestors used to use their hands each evening to mend or repair their possessions, or indeed to make new things. After a long day of physical work, the task of mending fishing nets or children's clothes, or making new implements for their homes, gave people a chance to reflect upon their day, to sit in silence or quietly converse with their

family, while they processed the dramas, the frustrations and the challenges of the day, and talked about the joys, the discoveries and the pleasures of daily life as well. This is not to suggest that all was romantic, of course, but spending time with our hands on 'honest work' allows our minds to seek solutions, to work through sadness and to deal with difficult aspects of life.

Nowadays we might spend our evenings curled up on a couch, with a television shouting at us and a device in our hands giving us direct access to the amazing parts of someone else's day. Our lives have become a strange juxtaposition, where we are connected with anyone, anywhere, at any time, yet at the same time we are not actually very connected with ourselves. While online connections can be amazing, interesting and inspiring, they can also lead to feelings of self-doubt and hopelessness, and to worries that we are missing out on all the good things in life. The things we feel happy about can seem much less appealing if someone else is living what appears to be a 'better life'.

Rather than mindlessly consuming someone else's output, we can choose to use our hands to create our own positive feelings. By focusing on our personal needs, and slowing down to listen to our own thoughts, we can give real space and quiet dedication to our need to be heard. Working through our fears and our sadness, in a creative state of slow quiet, is a joyful, though sometimes unpredictable, outcome of being a maker. The fact that we can tap into something that our ancestors spent their time doing every day reminds us, too, of how connected we really are – and how the human condition, complete with challenges and hardships, is not so different after all.

Community & Connections
of Being a Maker

Some days, sitting at our kitchen table or in our studio, we can feel isolated and lonely. With a work life driving us into the ground or children running us ragged, it can feel like we are all alone in this big world, and that our days – indeed, our lives – are harder than they need to be. Thoughts and feelings of no one understanding us can easily creep in.

Being a maker, we can choose to sit with the quiet of ourselves and our internal voice, shutting out the world to further understand who we are and who we might be. Or we can open ourselves up to connect with a

wider community of makers, to find that we are all travelling similar paths in this world, and that our passions can unite us and help us better understand each other. Whether you are a woodworker or a baker, a potter or a knitter, you can easily find a local community that will share your love of your craft and want to connect on a deeper level. You might find that you can swap tools, materials, patterns or recipes, or that someone is happy to teach you that tricky stitch you've been trying to work out. Or you might simply find someone to share your baking creations with, and a conversation about the challenges of finding the right ingredients in your part of the world.

OPENING OUR HEARTS AND MINDS

Stepping outside our homes and taking the sometimes scary journey to meet our community is often so well rewarded we wonder why it took us so long. If you're new in your town or country, a makers' group provides a wonderful welcome into a new group of friends. Once

you sit down and talk about yarn, colours, materials or techniques, it doesn't matter where you came from, what your income is or your job title; what seems to matter most is that as humans we can all connect on a basic level of sharing and learning our skills.

Putting yourself out into the community, regardless of whether you are a new or a very experienced maker, allows others to share their skills with you, or learn techniques that you have developed over time. Sitting quietly at your work table or in your studio, while absolutely necessary for certain aspects of our self and our work, needs to be complemented by conversing and connecting with another human being on a real level – looking them in the eyes while you crochet a string bag or a tea cosy together, or standing side by side while you carve a spoon, or learn how to use a new tool.

DIFFERENT VOICES

The online world of makers is encouraging and generous indeed, but stepping past it into our real

communities allows us to see people in our everyday lives, to open up to our differences, to respect the challenges that other people and other experiences can bring to our crafts. Sometimes staying in an online community means you're sitting within a group of very like-minded people, and not really learning about larger aspects of the world. Finding people who come from your hometown but who have lived different lives to you allows you to explore a new way of thinking and of relating to the world. By connecting with someone else over quilting or pottery, painting or knitting, baking or metalwork – it doesn't matter which – you will find that you open up a deeper way of seeing the world, which allows you to question where and how you might sit within it.

Doing something with our hands allows us to feel both productive and connected to a sense of something bigger. If we can let go of any prejudices we might be holding tight, we can see that other people have a different insight to us, which is equally important to

give space and listen to. By sitting and making together, we can create a community that represents each of us – giving voices to those who feel shy or insecure, and to others whose voices are often misrepresented or ignored. And those whose voices seem the loudest can be guided to align themselves to a gentler approach.

Being the best at the local craft group isn't the aim or even the ideal. Instead, we should be open to seek the best in everyone, finding a way to humble ourselves to fit cohesively within our community, to connect in a way that all our voices and opinions and ways of living can be shared, experienced and enjoyed. Speaking the loudest isn't always the best way, and using our hands to stitch, weave or make side-by-side allows the quietest to have their say as well.

Being Gentle
with your
Perfectionism

Sometimes, in life in general and as a creative maker, being a perfectionist is a great thing. It means things get done to an excellent standard, without having to worry about mistakes. But often perfectionism can pull us down into a spiral of negative feelings that we are not good enough. There can be a lot of stress or anxiety in wanting what we make to be perfect, or to look as good as someone else's. It sometimes feels that looking towards other people's creative making brings us down a little. Why bother making anything when someone else can make something better? Always pushing

ourselves higher and higher towards unachievable results isn't good for stress levels or our feeling of achievement; when nothing ends up being good enough we must start to think of new ways to approach both our making practice and the challenges of everyday life.

I myself am not a perfectionist, but my husband is forever making sure his circles are perfectly round and his lines straight and parallel. Some days I frustrate him no end with my imperfectionist tendencies, but other days I need to remind him that with perfectionism can come stressful emotions, or too much ego. Perfectionism propels one to keep on going further and further, which is a good thing, but not if the path becomes blocked and angry.

EMBRACING THE UNPREDICTABLE

Allowing the natural imperfections and challenges in our materials to guide us along a gentler path can be a great way to make small changes to a personality that is overly perfectionist. The way clay forms and moves on

its own accord means that a potter will always have to let go of their ideal vision of how a finished pot should look. The process of waiting for the clay to dry – the shifting weather patterns which might make one side of a bowl dry slower or quicker, and become thinner or fatter – is beyond the control of the perfectionist. The firing in a kiln has unpredictable aspects, regardless of how controlled the temperatures, glazes and cooling times; opening the kiln door always brings about that heart-in-mouth moment of waiting to see if the plate, cup or bowl came out as you imagined, or if you will have to change your viewpoint and see the beauty in the wonkiness, in the imperfections.

In my botanical dye work, I use plants and flowers to create colour on cloth, yarn or paper. Regardless of how accurately I follow a recipe, or aim to replicate a previous colour, each dye pot is unique, forcing me to let go of any expectations and see what the materials bring to the process. Sometimes by giving over to the mistakes that might happen, we open ourselves up to

the magic that we could never manufacture through a supposedly 'perfect' recipe.

By approaching our work with this idea in mind, we are already losing the tension that comes with ideals and hopes, which means our time at the work table or in the studio can become a place for playing with our materials, of hoping and dreaming but not holding tightly onto hard outcomes. This simple practice – which might take years of learning – can be brought from our creative work into our everyday life, where it can help us to be better able to approach the challenges of other people's imperfections, and to look at our ideals of a perfect world in a different light.

SEEING WITH NEW EYES

A failed cake, a crochet beanie that doesn't quite fit, or a quilt that becomes too puffy or buckled upon sewing: when the end result isn't right, all the hard work spent choosing our materials, our pattern or recipe, and all the time we put into making it can be disheartening. But by

stepping back and breathing for a moment before we throw out the cake or unravel the crochet, we can see things differently – all we need is some more cream and berries, or a different size head. An imperfect handmade quilt with wonky stitches still warms a bed and will forever be more beautiful than anything that can be purchased from a shop.

Often when we are making, the materials simply dictate the end result, again and again, over and over, reminding us about the imperfections in making, and in life. Forgiving the imperfections in our work reminds us to forgive the imperfections in ourselves, our relationships with others and the small mistakes we make every single day. Being gentle with ourselves and with our human foibles helps us to feel more at ease in who we are.

The Importance of
Taking a Break

Becoming deeply engrossed in what we are making can be fun and exciting, as well as meditative when we slip into the flow, but it also can consume us. We can become so immersed in the work we are creating that we can lose track of all sense of time and space, forget to sip our drink or look around us at the shadows shifting across the walls. This intense focus can feel amazing, and it allows us to work productively and delve into a deeper sense of our creative work, but it can also mean that we are living in a bubble in our head rather than truly attuned to the world around us.

As a society, we can forget to simply sit and be part of the quietness of the world. It seems, from my

humble experience, that the simple act of sitting quietly is an important aspect of practising a mindful way of living. By making sure we take a break during our making practice, we allow ourselves to recharge, and reconnect with the world around us.

CONNECTING TO THE OUTSIDE WORLD

Being part of our environment, rather than sitting separate to the world, is an aspect of mindfulness that allows us to feel and think in a deeper manner. It demands of us a compassion that can be missing with too much internal conversation or intense focus on our work. When we look around and notice other people, wildlife or nature – even simply let the sun settle on our face for a moment – we move outside ourselves and become more deeply connected with the world around us. Living in society with others means we become better human beings when we show connection and compassion, rather than only looking inwards at our

own work, and only breathing or thinking or feeling our own emotions. Rushing towards finished projects, deadlines and expectations, or even simply appointments and events, means we are rarely centred or connected to the moment, or to the people we're surrounded by, but rather are caught up in a whirlwind that we have no control over.

NOURISHING OURSELVES

Modern society seems intent on being busy, where there isn't time to stop for a moment and look up from our work, chores or extra-curricular activities. People rush around, working dedicatedly on finishing work, attending to projects or pleasing other people and meeting their needs. Yet studies and reports – and simple conversations with others – show us that this is creating anxiety, illness, depression and a sense of overwhelm that our community doesn't know how to deal with, and our health departments aren't equipped for. Learning, in your making practice, to stop and take

a break, will hopefully help you to remember during a busy work day, or with the noise of children around you, to step back, even just for one moment, and simply do nothing but soak up the sunshine or feel the breeze upon your face.

Often we are so caught up in our work that the very simple task of sipping water is forgotten, and there is no time for food to be eaten. After time our bodies are worn down by being treated this way and cannot sustain us, or indeed our creative minds. Setting time aside during the day to put down our tools, leave our work behind and replenish our bodies is vital to a healthy way of living, and a peaceful outlook on life. While it may seem counter to popular practice, it will allow you to notice how deeply you needed the space, time and quiet. A break can be as simple as stepping outside into the garden, or standing up straight and looking at the sky, but this moment of stopping work allows your body the chance to stretch and re-energize itself, your eyes the opportunity to focus on something

else for a moment, and your brain the space to stop the whirling thoughts.

Our practice at yoga, meditation or our daily making projects can guide us in our everyday experiences. The gentle reminders to nourish our body, to reassess our posture and give our minds quiet space means these practices become almost like second nature to us, and can be taken into our busy workplaces, or into the chaos of family life. We find that by practising simple moments with the joys of our making, we can use these as anchors to hold onto in the harder times, where life pulls us strongly in multiple directions. Learning simple ways of bringing slow across all aspects of our life is the hope of being a mindful maker.

The Journey
of Making

The harshness of life and other people's expectations can constantly force us to be always looking forwards to the allure of what our successes will bring, or towards what someone else thinks we should be aiming for. Sometimes chasing a future success helps to propel us and gives us momentum, but other times it makes us feel unworthy, like we have failed already, or are not living up to our perceived best life.

If we take away the goal of the finish line, and instead simply stop and focus on the journey, a lot of the anxiety falls away. Rather than always worrying about what others are doing better than us, we can remind ourselves that their journey could be very different to ours. Giving yourself the freedom to stop chasing ideals or dreams, and to simply sit with the reality of today slows us down – into our breath, our bodies and the raw potential of this moment, right now.

IT'S ABOUT THE JOURNEY, NOT THE DESTINATION

Of course, this can be a hard thing, when family, friends, work or society seem to always be dragging us along and telling us the goals we should be aiming for. But if in your making work, you allow your hands to guide you along a journey, rather than rushing for the destination, you can learn to settle into being contented with where you are right here, right now – and perhaps the project will be more enjoyable, too.

Process-led making is where we focus intently on the work in our hands, and the enjoyment comes from the physical act of making something, without forward-thinking too much about what that 'something' might look like. For example, we might take a ball of clay and simply play with it, allowing the clay and our hands to work together, for shapes to form and evolve; rather than our minds dictating what we are making, we are just seeing what the actual process of playing with clay can feel like. Without having to always plan for a finished pot or piece to show off, process-led making gives us space to simply lean into being present along the path we are currently on.

Some crafts are more aligned to this style of working than others. Take quilt-making for instance; when making a traditional quilt you might gather all the fabrics you need, lay them out and pre-plan what the end result will look like. The act of sewing and hand quilting can be very beautiful and mindful, but you are mostly always focused on when the quilt will be

finished, and if it will match up to your original plan. With process-led making, perhaps instead you might take some cloth and a length of thread, and simply start stitching something. Let the thread go for a walk along the fabric. Rather than thinking about lining up seams or whether colour combinations will work out right, the process of stitching becomes the focus, as you allow your breath to settle while watching each single stitch. To bring this practice into your quilt-making, you simply need to change your viewpoint on your work; think about each piece of fabric as it comes to you, and don't over-think the end result. Letting go of the structure of a quilt allows the process of the quilting to guide you.

THE SLOW JOY
OF STITCH AFTER STITCH

When we have an end result in mind, often we keep trying to rush towards it, wanting to see what it looks like. If we take away the idea of a finished piece

indicating the success of the whole project, we are able to enjoy the experience of making in a new way – not to have a quilt or a finished pot to hold, or a new knitted hat, but simply as making for making's sake and nothing more. Simply letting our knitting needles do the slow work of row after row, adding bits here and there in little moments of our days, means we are able to see the project as a meditative act of slowing ourselves down.

Of course it is pleasurable to have a purpose to our projects, and not to be always working on something that is never completed, but by taking away the hard deadlines and the visions of the end result, you are able to reframe your thought process about your projects, and see that the very simple act of making, stitch after stitch after stitch, can remind you why you started making in the first place, and where the true joy lies.

Clearing Up

At the end of a creative session in our studio or work space, it can feel like clearing up is the last thing we want to do. Yet taking the time to wash, clean and tidy away our tools and equipment with respect and gratitude is a meaningful way to end our making session. If we give ourselves this time to care for our tools, and process any thoughts that might have arisen during the session, we are honouring the fact that making is more than simply the outcome of a project.

THE RITUAL OF TIDYING

Just as we may begin our practice with a ritual to bridge the space between our everyday lives and our creative

making time, so too can the practice of clearing up and tidying away become a ritual end piece to our work. Often the cleaning-up time is a quiet and slow way to gather our thoughts; as we gather up our supplies, we can look back on what we have learnt that day, and collect our thoughts into a space where we can put them aside so we can re-enter the noisy world with a clear head. Rather than rushing away with half-finished work and messy tools, we are reminding ourselves that even at the end we can mindfully complete a task. Five minutes of packing-up meditation, like a simple talking meditation at the end of a yoga class, is enough to create a space where our work feels more important than simply work.

The physical process of neatening my studio, or simply clearing away the kitchen table, always gives me just a few more minutes where I'm able to be clearly and consciously with my thoughts, where I'm able to stack them neatly while I fold and stack my fabric. If I find that I have emotions still to work through, I can

pack them away to wait for me until the next time I unfold my fabric, rather than bringing resentment, anger or frustration into my family life or friendships.

Taking small moments of mindfulness at the end of our making time also gives us a chance to take stock of our materials, so that we are not tempted to go away and acquire what we simply do not need. Through this process we can often notice that there is so much more abundance than we had realized, and find that we are more grateful for the simple tools and materials that we do have.

RESPECTING OUR TOOLS

As mindful makers, gratitude and respect for our tools and equipment is something that should be cultivated. We makers have tools and materials in our hands almost every day; some can last us a lifetime, while others might only be used a handful of times. Our modern throwaway society seems intent on creating things that aren't designed to last longer than a short

season of use, forcing us to purchase more, but it doesn't have to be this way. If we look closely at how we use and care for our tools, we may well find we can make them last longer. Not only does this mean we are caring for our individual tools, and the wider environment, but it also gives us a more thoughtful approach to other possessions in our life.

At the end of a making session, it is all too easy to throw our dirty paintbrushes in the sink and to tell ourselves we'll deal with them later. Yet this disregard is something that can be carried across into our wider lives – friendships have the potential to be a disposable item, if no care or attention is taken. While this may seem a large leap from a paintbrush to a friend, it is the attitude of how we approach all things that affects how we treat them.

By being mindful of and respectful to our tools and materials at the end of a making session, we are reminding ourselves that every aspect of our making work is important, even a simple single sewing needle

or a spool of thread. This reiterates in our minds how the small details of our lives are also important. In caring for the way we store our sewing needles, or in putting away our carving tools or knitting needles with mindful attention, we are telling ourselves that each tiny breath in life contributes to the whole of our day. A broken or rusty sewing needle can work to some degree to patch our fabric together, just as a ragged or broken breath will fill our body with oxygen, but neither are doing the job to the best of their abilities because we haven't given our full attention to either.

Contentment
& Meaning

In my everyday life I don't seek the excitement or fireworks of happiness, but instead choose to find the slow, steady thrum of contentment. If we look outside in the world for just a moment, it is easy to see that almost everyone is chasing the happiness goal, wanting their life to be filled up with only the most beautiful, intense and wonderful things, experiences, friendships, jobs. The happiness bubble can be valuable, and propel us along towards the next big, exciting thing, but equally it is very easy to fall into the trap of only seeking those intensely happy things. This can lead to a feeling that if those things are not happening to us, then life is boring and we are failing. If we can let go

of the goal of perfect happiness, and instead allow ourselves to be simply contented with where we are at, this brings about a shift in our minds and our bodies, where we are able to notice the small and minute moments that often pass by and can fill us up in a deeper, longer-lasting way.

BE TRUE TO YOURSELF

Making by hand gives us the chance to hop off the whirlwind of life and see things from our perspective, rather than being swallowed up by what others are saying we should feel, do, wear, say or experience. It is very easy to get dragged along and stop listening to our own whispers, because the world shouts very loudly. But we do have a choice in how we live our days. Rather than busily chasing everyone else's highs or ideals of happiness, we can, by immersing ourselves in our craft practice, distil moments of true clarity where we realize we don't want or need what the world is selling or forcing on us.

Choosing contentment or deep satisfaction in our making seems simple in theory, but can take time to continue practising, remembering and living. It is easy to be swayed by the world, with our family or friends looking outward towards what others are doing, and trying to pull us with them to keep up. Watching the happiness that others appear to be showing off can be tiring, and make us feel small.

But intense happiness, while wonderful for our souls and relationships, is fleeting and can dissipate as soon as we've noticed that we are experiencing it. The deep feelings of contentment last longer.

THE JOY OF CONTENTMENT

It is entirely possible to find joy in the contented moments, if you choose to. As I sit with my hand sewing and my naturally dyed fabrics, the imperfections of my stitches fill my soul in a way that not much else can – except walking in nature and conversing with my children perhaps. Making a quilt for my home will take

me hours and hours, little stitch by little stitch. I could easily go and buy something from a shop and be done with it, but neither the shopping trip nor the purchased quilt would bring me the feeling of immense, quiet joy that the slow hours of stitching bring me. I may feel a big bubble of happiness at the thrill of finding something in the shop that is the right colour and price, but that happiness falls away quite quickly, to be replaced by a hollowness that desires to be filled again, probably with more shopping.

The deep joy of making something lasts longer because it is imbued with my emotions, ethos and values, as well as the physical memory of my hands working the cloth, and the mindful feelings that naturally come from our time spent with our making. Looking at something made by my hands reminds me in a way that is hard to describe to others why I choose this life again and again. The slow, quiet and often monotonous task of making something is about more than simply a scrap of wood, clay or cloth. The cake or

loaf of bread made and baked by me brings a satisfaction in sharing joyfully with my family or friends. Nourishing someone else with the things I make nourishes me in the gifting and the making.

Making can be the most soul-enriching and uplifting experience, giving us the satisfaction of taking our materials and forming them into a thing we can hold and share, or run our fingers across the imperfections. This is a feeling that lives long past the initial happiness stage. When we are not waiting for or forcing endless exciting moments into every day, we can experience contentment in the simple moments, and bring more joy and deeper meaning into our lives.

ACKNOWLEDGEMENTS

Many thanks go to Claire Saunders for her thoughtful edits, and for helping guide me through this process. And to Monica Perdoni for her encouragement.

To my father, Eric, for his guidance, words and insights into meditation, art-making and creative work, and for telling me that where I am right now is where I'm meant to be.

My husband, Sam, for loving me and all my creative mess, and making me cups of tea. And my three creative children, Ari, Mishi and River, for being the delightful noise in my life, and for sitting by my side when we make something together.

And deepest love to my mother, Michele, for teaching me the love of fabric, of making, and my deep connection with nature and our Earth.